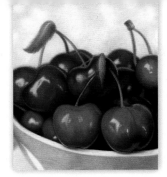

Colored Pencil Basics

The power to turn a photograph into a work of art is at your fingertips as long as you're holding a colored pencil! In this book, award-winning artist Cynthia Knox teaches the techniques and wonders of colored pencils using beautiful photographs as her guide. With Cynthia's expert recommendations, you will first learn how to select your pencils, paper, and optional art materials. Cynthia then guides you through basic colored-pencil techniques, including burnishing, blending, and layering, before demonstrating how to put those techniques into practice to create stunning colored pencil artwork of a cupcake, a butterfly, a filly, a bowl of cherries, and other unique subjects.

CONTENTS

Tools & Materials .2

Colored Pencil Techniques .4

Color Basics .7

Using Complementary Colors .8

Blending & Burnishing .12

Selecting Pencils .16

The Grid Method. .20

Enhancing a Photo Reference.24

Drawing Fur .28

I dedicate this book to my dad and close friend, Charles Everson,
who went to be with the Lord in July of 2011. Thank you, Dad,
for being such an encourager!

Tools & Materials

Colored pencil artwork requires few supplies. Many pencil brands are sold at reasonable prices in art stores and online; however, my advice is to purchase artist-grade, professional pencils. Student-grade pencils will not produce lasting works of art because the colors tend to fade quickly.

CHOOSING COLORED PENCILS

There are three types of colored pencils: wax-based, oil-based, and water-soluble. I recommend that you purchase a few of each, test them out, and see what you like and what looks great on paper.

Wax-Based

I prefer wax-based pencils for their creamy consistency and easy layering. There are a few drawbacks, however. They do wear down quickly, break more frequently, and leave pencil crumbs behind. This is easily manageable with careful sharpening, gradual pressure, and the use of a drafting brush to sweep away debris. Wax bloom, a waxy buildup that surfaces after numerous layers of application, may also occur. It is easy to remove by gently swiping a soft tissue over the area. Sanford Prismacolors® are popular and my personal favorite.

Oil-Based

These pencils produce generous color with very little breakage. There is no wax bloom and little pencil debris. They sharpen nicely and last longer than wax-based pencils. They can be harder to apply but are manageable when establishing color and building layers. Faber-Castell® Polychromos (German) and Caran d'Ache Pablo® (Swiss) are well-known brands.

Water-Soluble

These pencils have either wax-based or oil-based cores, which allow for a watercolor effect. Use them dry like a traditional colored pencil, or apply water to create a looser, flowing effect. This is especially nice for slightly blurred backgrounds. Sanford Prismacolor and Faber-Castell Albrecht Dürer pencils are good choices.

UNDERSTANDING PAPER TOOTH

Choose your paper based on the "tooth," or paper texture. Rougher paper contains more ridges than smoother paper. The paper's tooth will determine how many layers you can put down before the paper rips. Hot-pressed paper has less tooth and a smoother texture. Cold-pressed paper has more tooth and a rougher texture, which is excellent for water-soluble pencils.

Textured paper has defined ridges that accept many colored pencil layers without compromising the paper.

Smoother paper is less likely to accept multiple applications of color without ripping.

CHOOSING PAPER

I prefer Smooth Bristol paper from Strathmore®. Although it is a hot-pressed paper, it accepts many layers of color. I build up my colors with a lot of layering and burnishing, which involves using strong pressure to create a polished, more painterly surface. It is not unusual for me to use 10 to 15 layers of pencil, and I haven't ripped through this paper yet.

A lot of colored pencil artists prefer a paper called Rising Stonehenge, which can withstand numerous layers of pencil and has both smooth and rough sides. The smooth side is best for portraits and skin tones.

Additional surfaces include velour paper, museum board, suede mat board (great for animal fur), illustration board, wood, and sanded paper, which eats up pencils quickly but presents a beautiful, textured look.

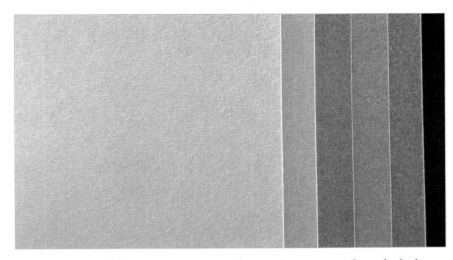

Experiment with different surface types, colors, and textures until you find what works for you.

USING ADDITIONAL TOOLS

Drawing Board

You can find drawing boards at any art store or online. Because I usually use 14" × 17" paper, I keep several drawing boards on hand that measure nearly 20" × 19". To prep the drawing board, I tape down a blank piece of my Smooth Bristol paper to create a cushion between my working surface and the board for a smoother color application.

Drawing boards with a cut-out handle are easy to transport. Before slipping them into my portfolio case, I clip a blank piece of Bristol paper over my original artwork and then cover the entire board with a plastic bag, such as a basic garbage bag.

Pencil Sharpener

I use an electronic pencil sharpener with a sturdy base. Every now and then, I sharpen a couple of graphite pencils in it to clean off the wax buildup on the blade.

Erasers

Unlike graphite, colored pencil pigment is not easy to erase; however, I use several types of erasers to eliminate unwanted marks and to lighten dense color. The Pink Pearl eraser gets rid of initial graphite sketch lines and helps clean up edges and borders of a finished piece. Kneaded erasers are great for lifting color. Just stretch off a piece, roll into a ball, and press down on the overly saturated color. Battery-powered erasers are great for eliminating color altogether, but they are likely to rip through paper or wear down the tooth.

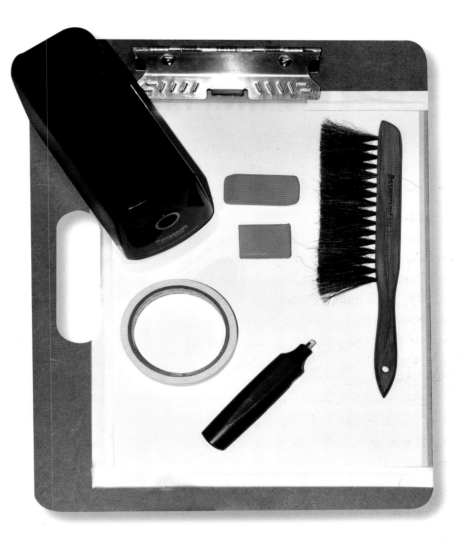

Drafting Brushes

I use two drafting brushes to keep my paper clean. I keep one next to my pencil sharpener and wipe newly sharpened pencil points across its bristles. I keep a second one in my left hand and use it to sweep pencil crumbs off my working surface. Both are valuable to keep pencil debris to a minimum.

Artist Tape

Artist tape looks and applies like masking tape, but it is white and peels off surfaces easily without leaving anything behind. It is great insurance against removing the top layer of paper or color.

Spray Fixative

Spray fixatives seal your artwork yet still allow you to make color changes. They prevent smudging and wax bloom from occurring. Before using, gently remove any wax bloom with a tissue or soft cloth. Step outside and make a few test sprays to eliminate any spitting. Then hold the can approximately six inches away from your artwork and spray in a smooth horizontal motion. Repeat in a vertical motion. Be sure to do this outside, as the fixatives are toxic.

Colored Pencil Techniques

Colored pencils are portable, inexpensive, and able to convey a diverse mix of textures, color densities, and finished looks. If your style leans toward sketches, use cold-pressed paper and bolder strokes with less layering. If you like a highly polished look similar to an oil painting, then choose hot-pressed paper, layer extensively, cover all of your paper with color, and burnish to a high gloss.

As artists, we want our artwork to reflect our personalities. We want to showcase our individual tastes through our choice of composition and colors. There are numerous techniques to achieve this, so let's explore the basics.

STROKES

How you hold your pencil and the amount of pressure you use determine the outcome of your finished piece. When laying down my first foundation of color, I lightly cover the entire area in a linear fashion, either horizontally (A), vertically (B), or diagonally. A technique called hatching involves the placement of parallel lines. Crosshatching (C) is the application of parallel lines over the initial set to increase density. These two techniques help to quickly cover large blocks of paper with color.

After several coats of broadly swept color, I hone in on specific areas to bring forth detail and realism. My strokes become smaller and more controlled. I use circular strokes (D) when I want to cover all of the paper but don't want any visible pencil patterns. I use small circles that keep overlapping each other until an entirely smooth surface emerges.

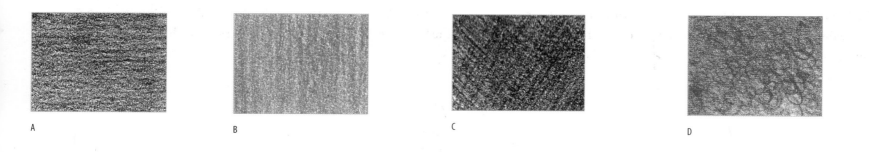

A B C D

PRESSURE AND SHADING

Pressure is everything. It determines whether you create a colored pencil drawing or a colored pencil painting. If you consistently use light pressure, your finished piece will look soft and airy. Discernible strokes with some paper showing through will contribute to a loosely drawn appearance. This is highly desirable with collectors who are looking for less finished pieces of art. On the other hand, heavy pressure with lots of layering and burnishing will yield a more painted look. This tends to be my preference, as I lean toward color saturation and extreme detail.

Gradual shading and increased pressure will take you from loose and soft to dark and fully saturated. A good drawing or painting should have both ends of the spectrum for contrast. To get the feel for shading, create a shading bar using your favorite color. This will help you develop wrist control and a smooth progression from light to dark.

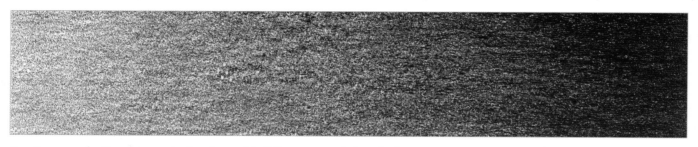

Practice your shading using a single color and building up to a darker shade using greater pressure and more layers.

BURNISHING

Burnishing is my favorite technique and perhaps my signature style. Some artists really don't like this and prefer instead to allow the paper texture and color to show through. I have seen some beautiful artwork where the strokes and paper surface are visible. On the other hand, I have always admired realistic oil paintings, and burnishing helps me achieve that look using colored pencils.

The burnishing process involves the last few applications of color. You burnish by applying a final color over the existing area of blended color using a heavier pressure than normal. Using a white colored pencil as a burnishing tool seems to "melt" the blended colors beneath it together. Some people use colorless blenders to accomplish the burnished look.

If a burnished area needs more color, simply add the color you think it needs on top. It will still receive it nicely.

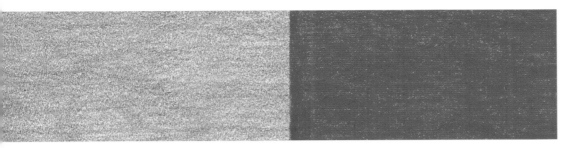

Burnishing over an area of color (left) creates a smooth, highly polished finish (right).

BLENDING AND LAYERING

Oil painters use a palette to mix their colors. Colored pencil artists use one color on top of another to achieve the desired shade. The blending process can be slow but rewarding. The more colors we use, the richer the final outcome. For example, I never use only black to create a black background. I will first cover the area with black, and then I'll add Tuscan red, followed by indigo blue, and finish with a burnished coat of black. This formula is pretty foolproof for creating a dense, rich background, whereas several layers of only black would create a flat background.

Practice layering and blending by starting out with a rectangular bar shape. Fill it in with a solid color throughout. One-third of the way into it, layer the remaining two-thirds with a second color. Lastly, use another color for the last third. Use light to medium pressure at all times with consistent application. You will see firsthand what the layering technique can accomplish.

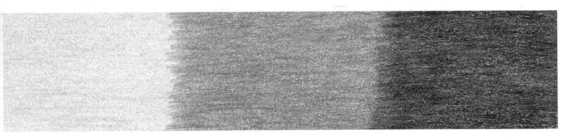

Use three (or more) colors to blend and layer, in the end creating a dense hue that's richer than a single color on its own.

WATERCOLOR EFFECTS

Water-soluble pencils have two uses: to create a traditional colored pencil look and to create a loose, watercolor effect when mixed with water. The simplest technique is to lay down several layers of dry color from a pencil and then lightly add water with a small brush. Instead of oversaturating your brush at once, build color with repeated brushings. After the area dries, you can then restore detail with dry color application.

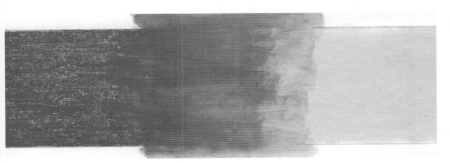

Dry blocks of water-soluble red and yellow take on a watercolor effect (middle) with water from a small brush.

SELECTING COLOR

To determine which colors I need to use in a painting, I use the "value viewer" method. Ann Kullberg, a leader in the colored-pencil world, developed value viewers, which consist of two-inch pieces of laminated white paper with a single hole punched in the center of each. First I place one value viewer over an area of color in my photo. Then I make three to four pencil choices and layer them onto a sheet of practice paper. Next I place the second value viewer over my swatch to see how the color matches up to the color in the photo. I keep playing with the color combinations on my scrap paper until it matches the colors in my photo. Once I have a match, I write down the pencil names in the order that I used them. I continue this process until I have identified all of the colors I need to complete the project. Remember, it's okay if your colors don't match perfectly.

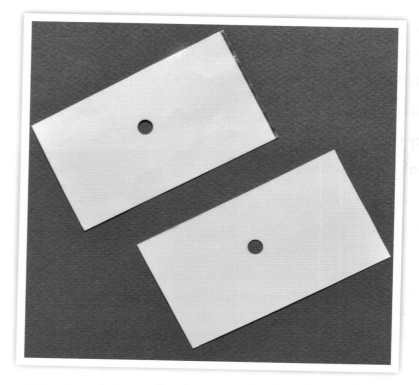

Value viewers help you select the correct colored pencils to match your photo references.

COLOR REMOVAL

If you have oversaturated an area or if your blended colors just don't look right, you have a couple options. First, take a piece of tape (Scotch® tape will do nicely) and gently apply a swatch of it over the offensive area. Press down and then very gently peel up. *Voilà!* You have removed several layers of color. Repeat until you have a decent base upon which to start again.

The second option is to white out the offending area with your white colored pencil. This works well if you have built up many layers of color and the surface has become somewhat slick. If I detail something with a pencil that just doesn't work or if I lay down the wrong color, I take my white pencil with an extremely sharp point and white out the whole area. It's amazing. The previous colors are completely gone, and it is possible to start over, adding just a few more applications of color.

Likewise, when laying down initial coats of color, sometimes the pencil will leave dark specks. To eliminate the specks, apply a very sharp white pencil point over them.

▶ *A white colored pencil with a very sharp point can cover up mistakes in your composition.*

Color Basics

Colored pencils are transparent by nature, so you build color density by layering rather than mixing colors together on a palette. Understanding why certain colors work well together and why others don't is important. Color schemes create moods, and a chaotic visual can be turned into a calm one with just one or two color substitutions.

▶ *A color wheel, which you can purchase at an art store, makes it easy to revisit complementary color schemes.*

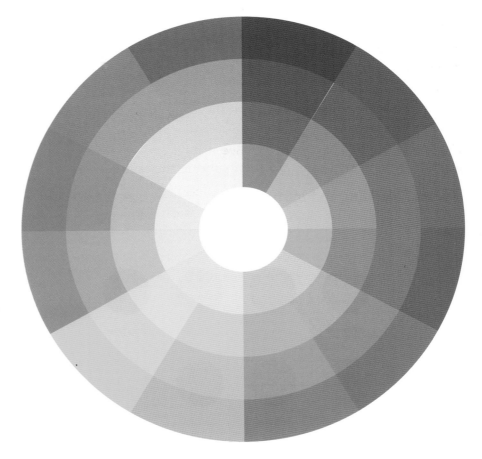

TYPES OF COLORS

Primary colors (red, yellow, and blue) are basic and cannot be created from mixing other colors. Secondary colors (orange, green, and purple) are a combination of two primaries. Tertiary colors (red-orange, red-purple, yellow-orange, yellow-green, blue-green, and blue-purple) are a combination of a primary color and a secondary color. Complementary colors are any two colors exactly opposite each other on the color wheel. Green and red, yellow and purple, and blue and orange are the main examples.

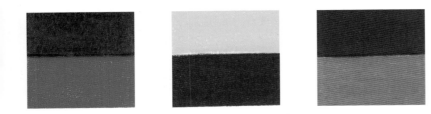

When placed together, complementary colors bring life to a composition and evoke strong responses from your viewers.

COLOR TEMPERATURES

The temperature of a color refers to the warmth or coolness that it conveys. Half of the color wheel involves reds and yellows (warm). Blues and greens (cool) comprise the other half. A good thing to remember about color temperature is that warm colors appear to come forward, and cool colors appear to recede. You can use this knowledge to create depth and emotion in a drawing or painting.

Using Complementary Colors

Complementary colors are two colors that are opposite each other on the color wheel. (See "Color Basics," page 7.) While we may not understand why these color combinations work so well, we instinctively know that they do. In this project, we'll use red and green, and you'll learn how to accentuate and then subdue the vivid colors with several layers of blending and burnishing.

crimson red Kelly green poppy red sienna brown

sunburst yellow Tuscan red terra cotta white

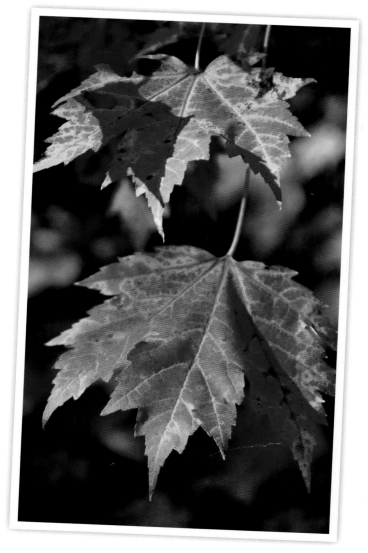

Autumn leaves near the peak of their splendor in the Northeast.

1. *I sketch an outline of the bottom leaf with an H graphite pencil. I will later erase these lines as I work on each section so the graphite doesn't show through the colored pencil.*

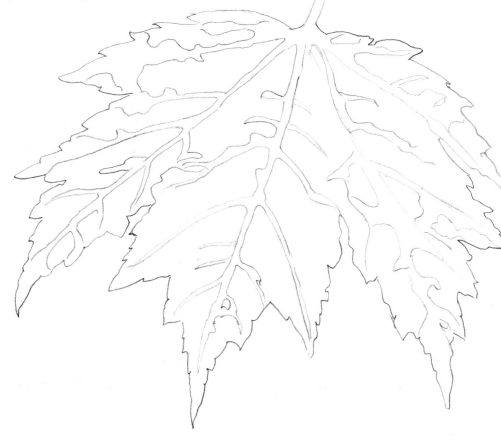

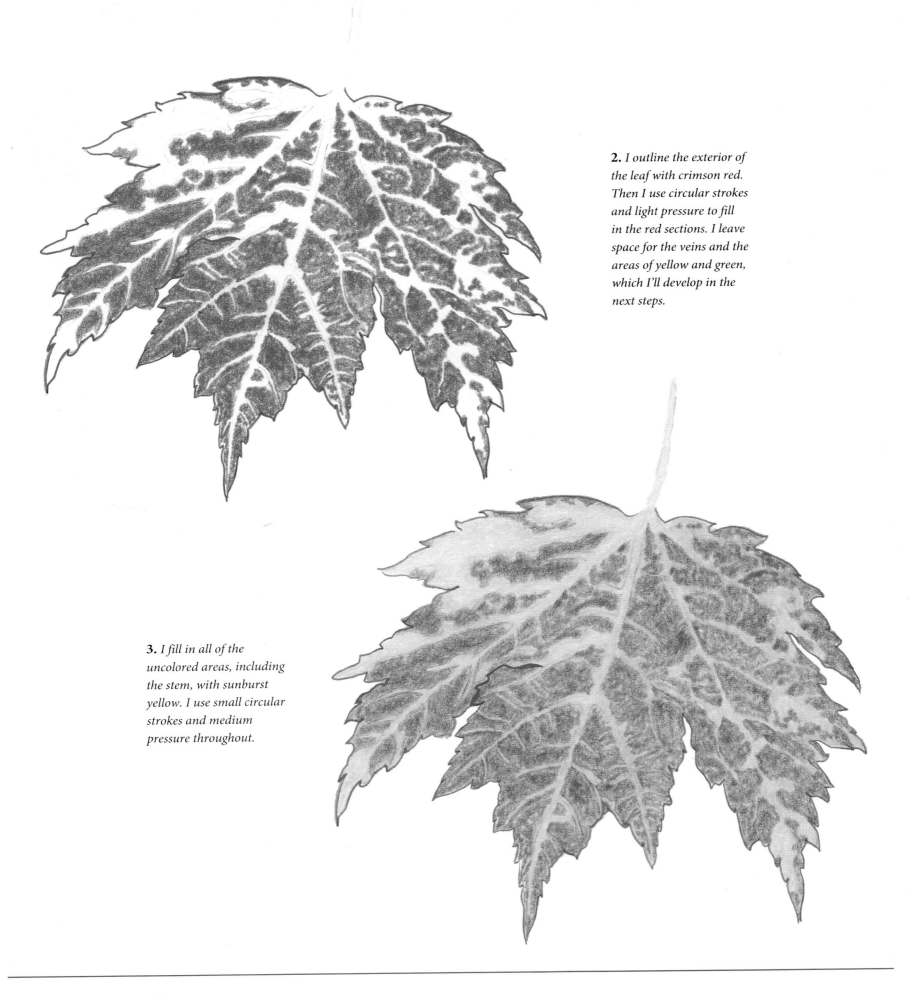

2. *I outline the exterior of the leaf with crimson red. Then I use circular strokes and light pressure to fill in the red sections. I leave space for the veins and the areas of yellow and green, which I'll develop in the next steps.*

3. *I fill in all of the uncolored areas, including the stem, with sunburst yellow. I use small circular strokes and medium pressure throughout.*

‒ ARTIST'S TIP ‒

Keep one finger on your reference photo as you're working. This helps you easily refer back and forth between your photo and your drawing without losing your place, and it prevents errors that will be difficult to correct.

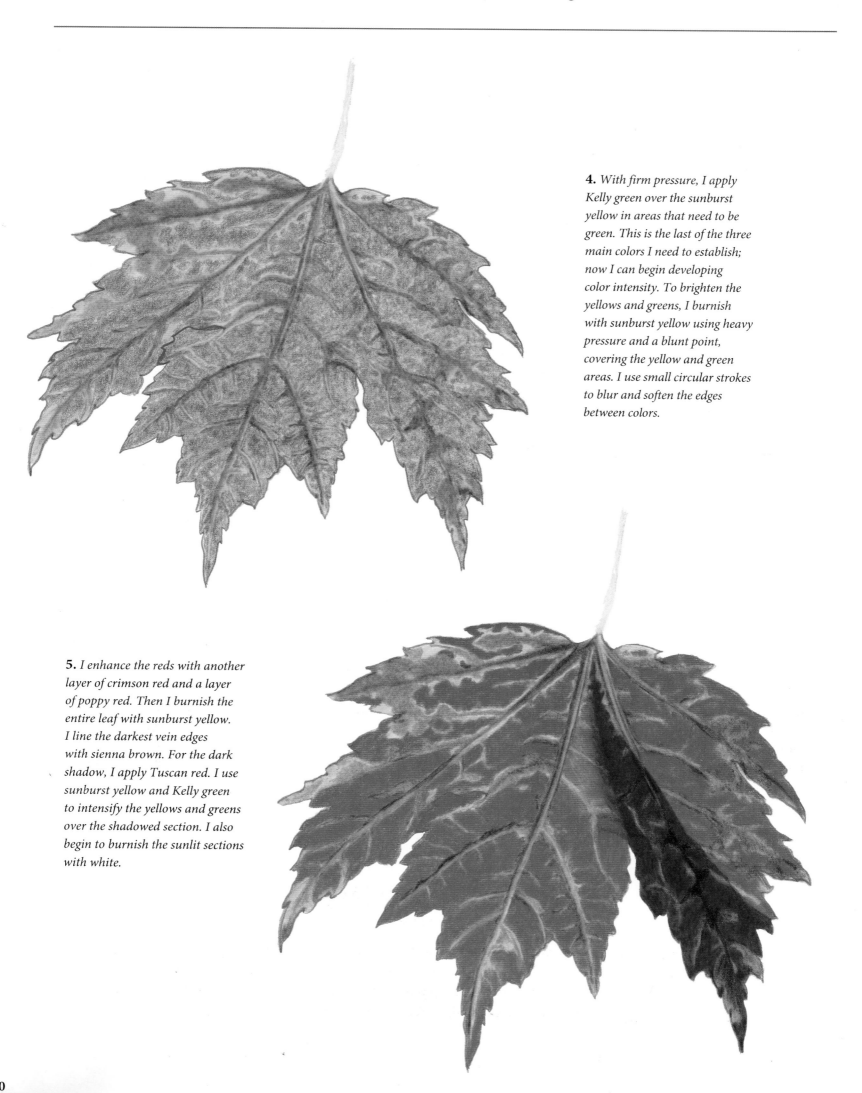

4. *With firm pressure, I apply Kelly green over the sunburst yellow in areas that need to be green. This is the last of the three main colors I need to establish; now I can begin developing color intensity. To brighten the yellows and greens, I burnish with sunburst yellow using heavy pressure and a blunt point, covering the yellow and green areas. I use small circular strokes to blur and soften the edges between colors.*

5. *I enhance the reds with another layer of crimson red and a layer of poppy red. Then I burnish the entire leaf with sunburst yellow. I line the darkest vein edges with sienna brown. For the dark shadow, I apply Tuscan red. I use sunburst yellow and Kelly green to intensify the yellows and greens over the shadowed section. I also begin to burnish the sunlit sections with white.*

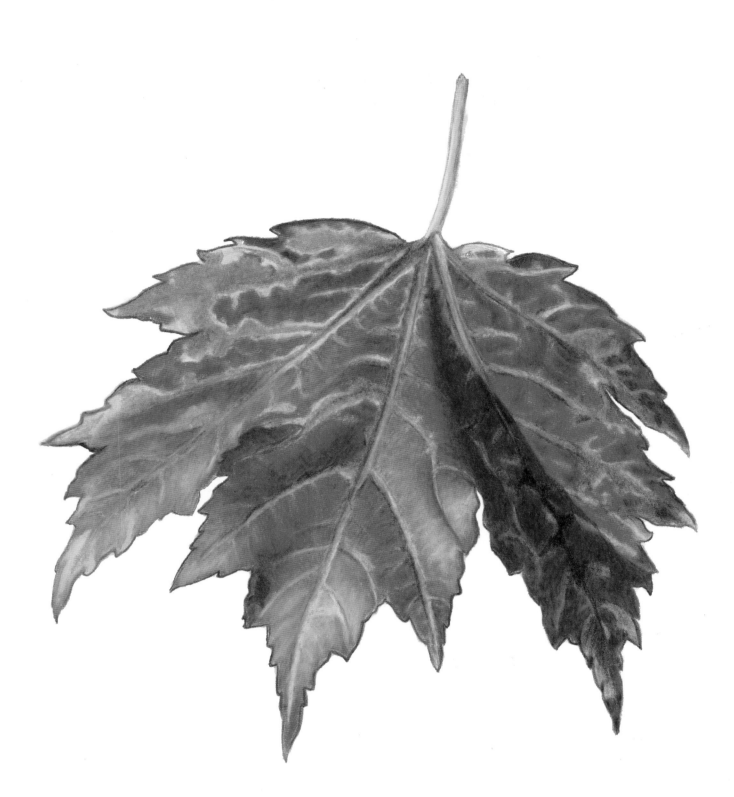

6. *Using Tuscan red with firm pressure, I intensify all of the dark red areas. I use Kelly green to darken and define the greens. I burnish the remaining sunlit sections with white, blending the colors together and pressing hard to bring out the highlights. I blend and burnish to restore the reds and yellows where needed. Then I outline the leaf with a sharp Tuscan red. I color the stem with sunburst yellow, add terra cotta down the right side. and then burnish with white. I draw a thin line of terra cotta down the left side of the stem for definition. I finish by erasing all smudges and spraying with workable fixative.*

TECHNIQUE PRIMER
S H A D O W S

Many beginning artists wrongly assume that heavier coats of a particular color will create a deep shadow. Instead, use darker colors to create shadows and contrasts. My favorite pencils for doing this include dark umber, Tuscan red, black grape, cool grey 70% and 90%, and black. Keep your strokes small and use a light touch to build density. If you overdo it or accidentally create dark marks, use a sharp white pencil to "erase" them.

Blending & Burnishing

This enjoyable project involves blending light colors into extremely dark colors seamlessly. The attractive lighting, unique colors, and beautiful design combine for a visual appeal that stimulates our creativity, as well as our appetites!

aquamarine black black grape burnt ochre cool grey 50%

cool grey 70% crimson red dark umber light green non-photo blue

process red pink slate grey terra cotta white

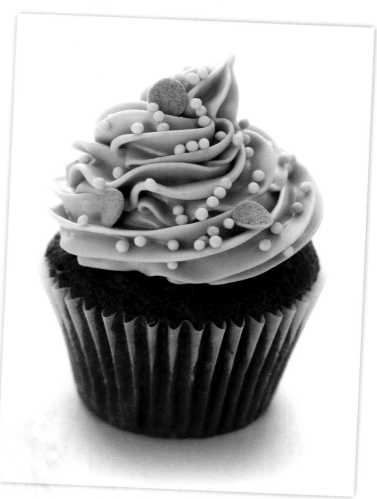

1. *I lightly sketch the cupcake with cool grey 50%. This neutral color will blend nicely with the bluish-green frosting hues.*

The frosting, expertly swirled into stiff layers, has defined edges that I will re-create using highlights and shadows.

TECHNIQUE PRIMER
PRESSURE

Use lighter pressure when you're in the early stages of a project and laying the groundwork of color. Then work up to stronger pressure for your shadows, as well as for blending and burnishing. I generally think of pressure on a scale of one to five, as noted below.

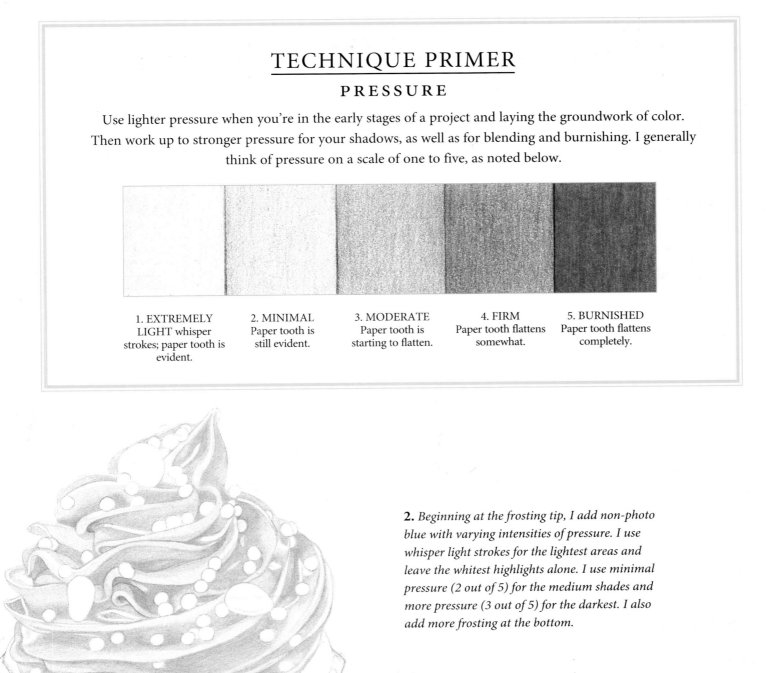

1. EXTREMELY LIGHT whisper strokes; paper tooth is evident.

2. MINIMAL Paper tooth is still evident.

3. MODERATE Paper tooth is starting to flatten.

4. FIRM Paper tooth flattens somewhat.

5. BURNISHED Paper tooth flattens completely.

2. *Beginning at the frosting tip, I add non-photo blue with varying intensities of pressure. I use whisper light strokes for the lightest areas and leave the whitest highlights alone. I use minimal pressure (2 out of 5) for the medium shades and more pressure (3 out of 5) for the darkest. I also add more frosting at the bottom.*

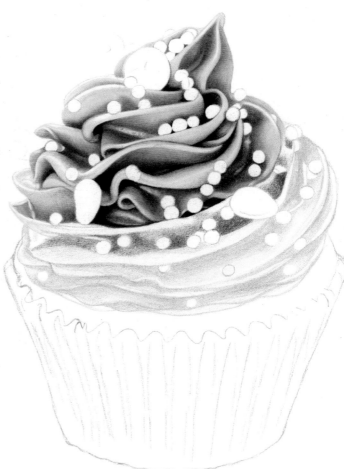

3. *Starting at the top and working downward, I add cool grey 70% for shadow definition where needed. Then I add aquamarine on top for color. I use white to blend the colors and blur the edges using small circular strokes and moderate pressure. I use slate grey to add a bluish-grey hue, and I use black for the darkest shadows. I add light green in a few areas and prep the next layer by adding the shadow in cool grey 70%.*

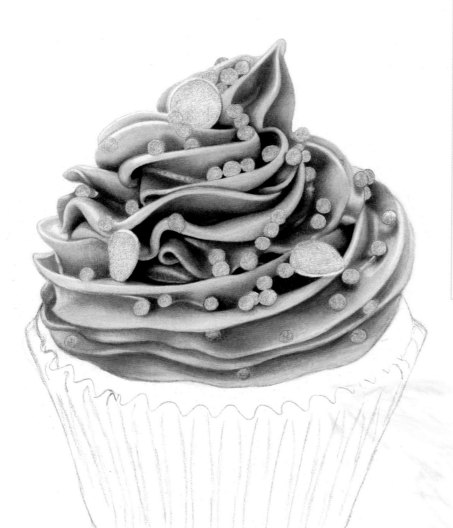

4. *Layer by layer, I finish the frosting using moderate pressure. I use cool grey 70% for the shadows and slate grey for a bluer hue. I apply aquamarine over the grey and aqua areas. I use white to blend and burnish and black in the deepest crevices. Occasionally, I use non-photo blue to add soft blue tints. I clean up the inside of the candy with an eraser; then I lightly re-line them in cool grey 50%. I fill in the small circles with pink using a soft circular motion.*

5. *I finish the small candy beads with another layer of pink and apply slate grey in the shadows. I burnish with white, and I follow with more pink where I need more intensity. I add process red over the pink for the brightest areas. I layer the wafers with pink and process red, and then I burnish with white. I use crimson red to add dots and dashes on the wafers. Then I lightly blur with a sharp white pencil. With an F graphite pencil, I re-draw the fluted lines of the wrapper and layer the darkest with dark umber. I add a base layer of dark umber for the cake.*

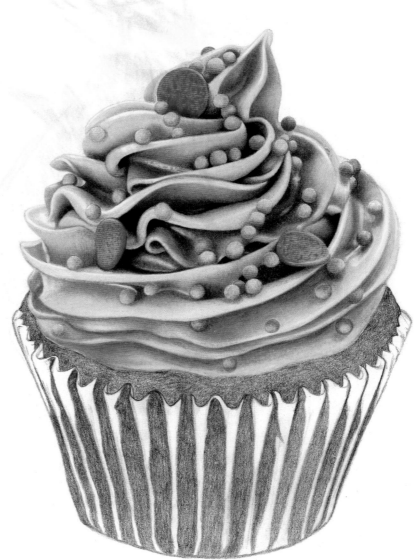

To blur two separate colors into each other, use tight circular strokes over the area where the colors meet. Use a white pencil or one of the colors on either side of the border.

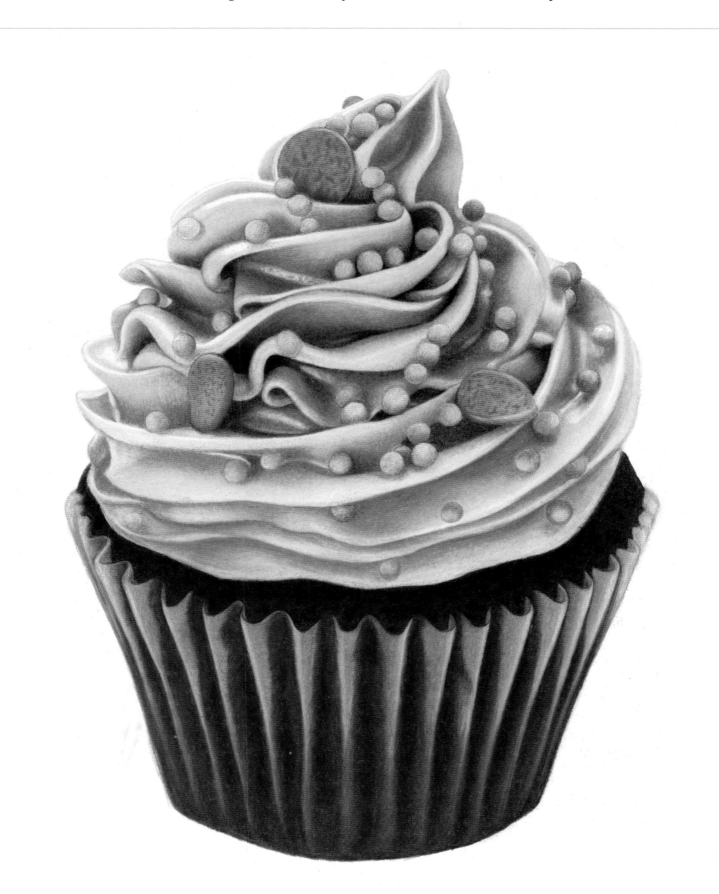

6. *I layer the cupcake with dark umber, followed by a light coat of black and a burnish of burnt ochre. I add a few black marks for texture and burnish with terra cotta. I darken areas of the wrapper with dark umber and terra cotta, burnish with white, and repeat several times. I add a bit of black in the darkest shadows. I use cool grey 50% and black grape to slightly darken the wrapper's top edges, followed with several layers of white and a soft touch of dark umber. I highlight the wrapper's vertical ridges with white; then I blur the far edges. I use dark umber to line the wrapper bottom.*

Selecting Pencils

One of the most challenging yet rewarding tasks with a new project is choosing which pencils to use. Rather than guessing while in the midst of a project, I select the colors I will need in advance. A trial-and-error approach to blending swatches is the best way to start. I often test multiple pencils and different color combinations until I find a hue that approximates a specific area of color in my photo reference. Keep in mind that your pencil selections don't have to match exactly—feel free to take liberties!

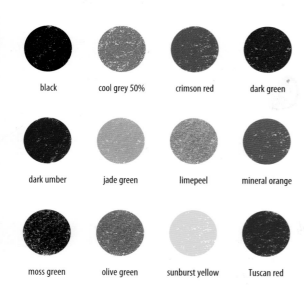

black cool grey 50% crimson red dark green

dark umber jade green limepeel mineral orange

moss green olive green sunburst yellow Tuscan red

white

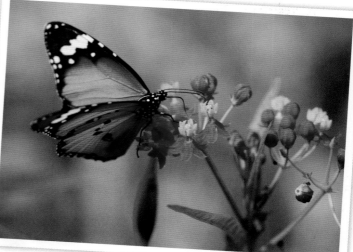

I plan to remove the blurred tree you see in the background of the photo.

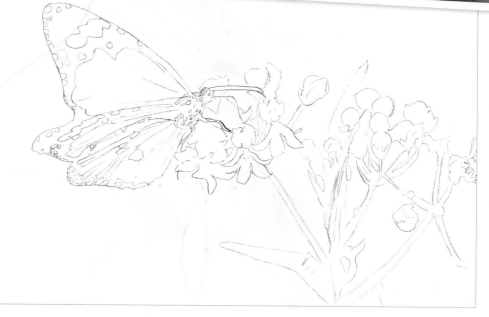

1. *I outline the butterfly, flowers, and leaves with cool grey 50%. This is a neutral color that won't compete with future color applications.*

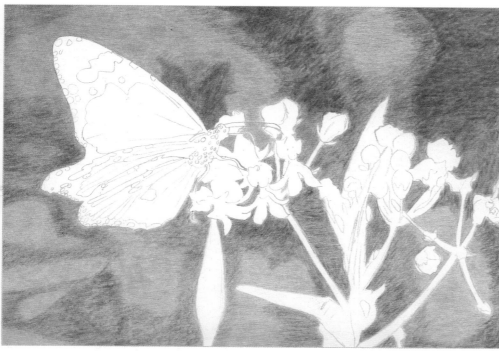

2. *I select limepeel as the dominant color to use in the background and apply two layers using horizontal strokes. I cover darker areas with moss green and lighter areas with olive green.*

TECHNIQUE PRIMER

CHOOSING COLORS

I start with an 8" × 10" photo and sit near a window with good daytime lighting. Using the value viewers (see "Selecting Color," on page 6), I isolate an area of the photo and choose pencils that look similar. On a white sheet of paper, I draw a swatch of color, place the value viewer over it, and compare it to the color I see in the value viewer over my photo. This helps me see how closely the swatch I've created matches the color in the photo. I keep testing pencil combinations until I'm satisfied. I write down the pencil names that make up the final blended color, as well as the areas I'll use them in. I move on to the next color in the photo and repeat the process.

LAYERING COLORS

Rather than simply using one green pencil to color a green area or a black pencil to color black areas, I build each area of color in layers. These four swatches illustrate how I build many of the green areas in the project and all of the black areas on the butterfly.

1. Limepeel, moss green, olive green

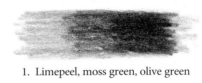

2. Limepeel, moss green, olive green, white burnish

3. Limepeel, moss green, olive green, white burnish, sunburst yellow burnish, dark umber

4. Tuscan red, crimson red, black

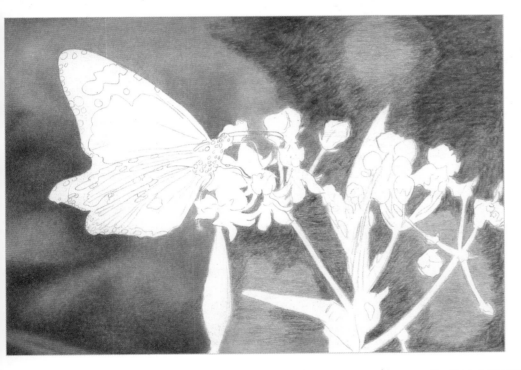

3. *I burnish half of the background with white using circular strokes and heavy pressure. Moving left to right, I add layers of moss green and olive green, followed by dark umber over the darkest sections. Next I burnish extensively with sunburst yellow over the green areas. I tone down and blur overly dark areas with white, as needed.*

4. *I complete the background with a burnish of white using circular strokes. I add moss green, olive green, and dark umber for color intensity; then I burnish with sunburst yellow. I use black, dark umber, and dark green over the darkest areas, and a touch of Tuscan red for a reddish-brown tint.*

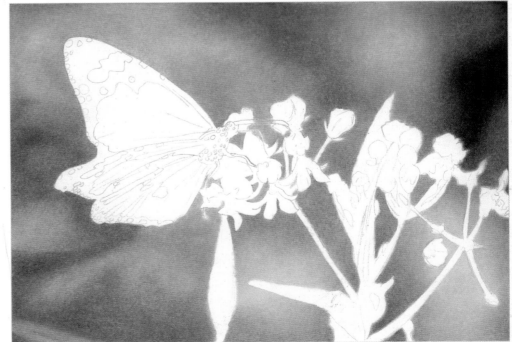

Rich reds, greens, and deep blues are excellent foundation colors to apply before adding the final layer of black. The result is a dense, dramatic hue.

5. *I begin the butterfly with a base coat of Tuscan red in the black wing and body areas. I lay a foundation of mineral orange in all other areas except for the white spots.*

6. *I layer crimson red then black over the Tuscan red. I add another coat over the mineral orange, followed by sunburst yellow over that. On the upper wing, I add crimson red, burnish white, and brighten with sunburst yellow. I line the veins with Tuscan red and crimson red; then I burnish streaks of white just above them. On the lower wing, I apply Tuscan red, followed by crimson red over the veins and other red areas. I use sunburst yellow, mineral orange, and a touch of Tuscan red to darken. I use dark umber with a black topcoat for the shadow. I fill in the spots and outline the left upper wing with white. I use Tuscan red and white on the shadowed spots. I begin the flowers with layers of crimson red, sunburst yellow, and mineral orange.*

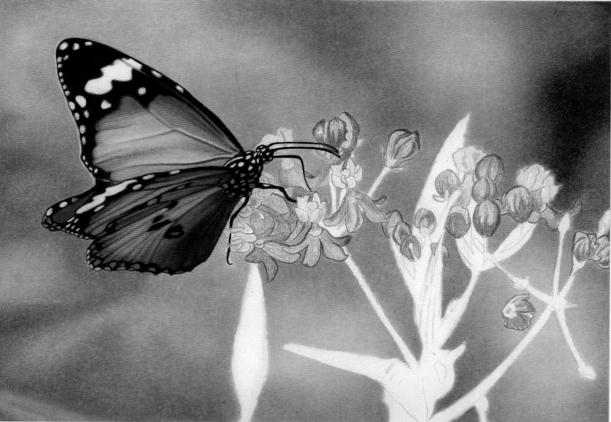

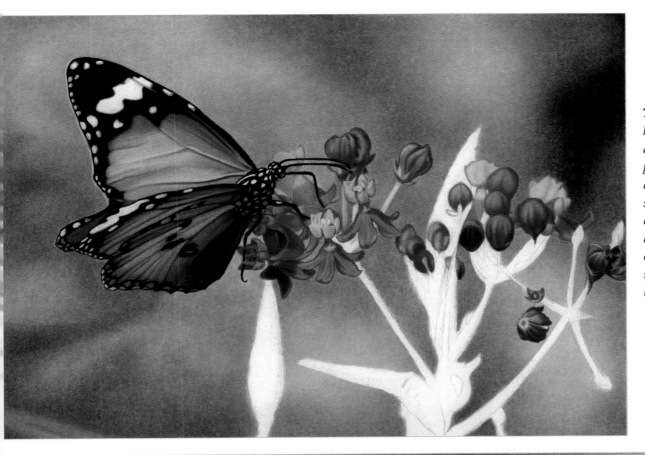

7. *I complete each flower from left to right. I use Tuscan red and black to shadow the reds, plus a crimson red topcoat. I color the yellow flowers with sunburst yellow and mineral orange. I use sunburst yellow and mineral orange for the orange flowers with crimson red streaks and a light touch of black for the shadows.*

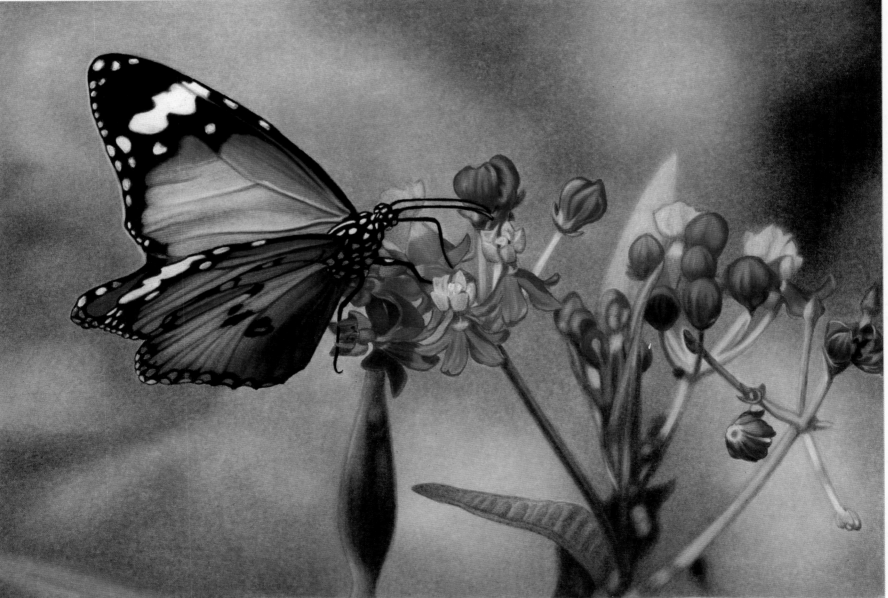

8. *I use olive green for the dark leaves and stems and dark umber in the brown areas; then I burnish with white and sunburst yellow. For the lighter leaves and stems, I use limepeel, sunburst yellow, and olive green. The lightest leaf gets jade green, limepeel, and a burnish of white. I layer the textured leaf with olive green, limepeel, dark green, and a white burnish. I use olive green and a white outline to create the ripples; then I blend with sunburst yellow. I outline with dark umber and blend with white.*

The Grid Method

Drawing and painting horses is very rewarding. But what makes them the beautiful animals they are—namely their strong musculature, shiny coats, and flowing manes—can also make them challenging to draw. In this project, I'll show you how to use the grid method to create your initial sketch and explore how to create different textures with colored pencils.

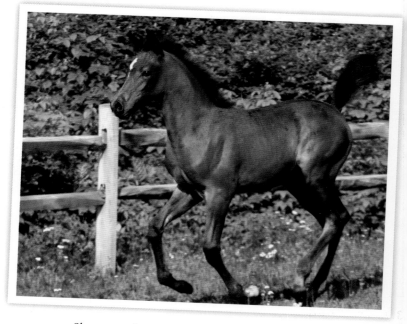

Shana, my friend's filly, was three months old in this photo.

apple green	black	black grape	burnt ochre	chartreuse	cool grey 50%
dark brown	dark green	dark umber	ginger root	indigo blue	light umber
lilac	moss green	peach beige	terra cotta	Tuscan red	white

1. *I create a sketch using cool grey 50%. Then I layer ginger root using medium pressure to establish a foundation for the fur, stroking in the direction of the fur.*

2. *I apply two layers of burnt ochre over the face and neck; then I lay in black over the dark areas using a light touch on the face and firmer pressure on the eye, nose, and jaw. I burnish all but the black areas with white. I shade the brown of the face below the eye with dark umber and add terra cotta to the area above the brow.*

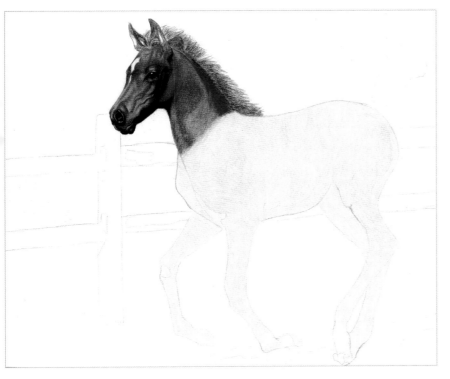

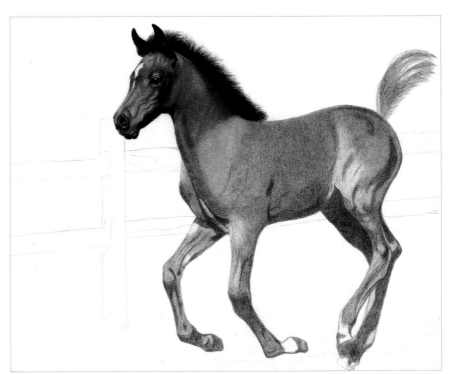

3. *I use terra cotta, dark umber, and white to add the forehead markings. I use black, dark umber, and Tuscan red for the eyebrow and white for the eyelid. I use dark umber for the markings below the eye and over the face, and I use terra cotta for the reddish areas. I blend with white; then I use black grape over the dark side of the face and above the jaw. I finish the nose and mouth with black, dark umber, and black grape. I use Tuscan red to blend the heavy side markings and use black grape for the neck markings. I sketch the ears and mane with black; then I use Tuscan red and dark umber for the fur closest to the mane.*

4. *I burnish the neck with white and apply burnt ochre. I layer in dark brown and terra cotta. I use dark umber for the dark markings and add Tuscan red in the reddish areas. I blend everything with terra cotta and use white to lighten. I use terra cotta, black, and Tuscan Red for just below the mane; then I fill in the dark ear areas with indigo blue and black. I use terra cotta in the reddish areas and then blend into black. I use indigo blue and black for the mane with a few thin white streaks. I layer the rest of the body with two coats of burnt ochre; then I block in the dark areas and tail with dark umber. I burnish with white below the neck.*

TECHNIQUE PRIMER
DRAWING FROM A GRID

There are several ways to transfer a photographic reference onto your drawing paper. The grid method is a quick and accurate technique that helps to ensure correct proportions. Photocopy your image; then draw a grid of one-inch squares over it with a pen and ruler. Lightly draw the same grid with a graphite pencil onto your drawing paper. Fill in the boxes on your drawing paper by moving from left to right and drawing what you see in the square that corresponds to the photo. Connect your composition from box to box until complete. Erase the grid lines, and begin with your colored pencils.

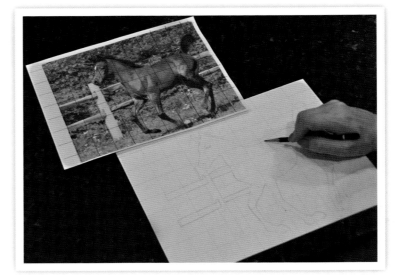

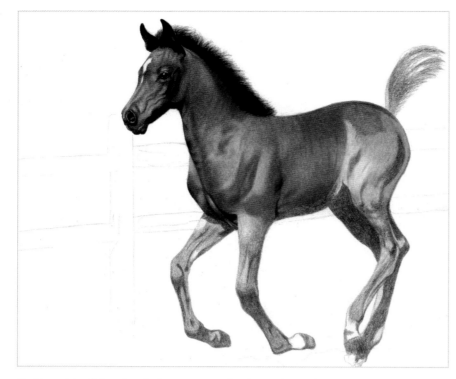

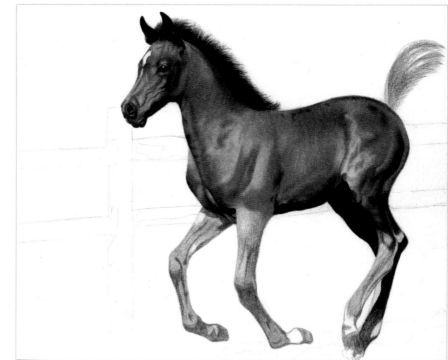

5. *I burnish all but the darkest areas with white. I layer the midsection with burnt ochre and terra cotta. I apply black grape over the upper back and blend with white into the lower torso, repeating several times using curved strokes until smooth. I use terra cotta and Tuscan red to intensify the reddish areas. I use black grape, black, dark umber, and terra cotta to complete the neck and chest.*

6. *I burnish black over the dark stomach, hip, and lower leg areas; then I blend in Tuscan red and terra cotta. At the top of the hip, I block in the reddish-brown areas with burnt ochre and the dark areas with dark umber. I layer black grape at the top and terra cotta over the hip and into the left leg. I highlight with burnt ochre and light umber; then I burnish with white. I add another layer of light umber to darken slightly. For the back end, I use burnt ochre and black grape.*

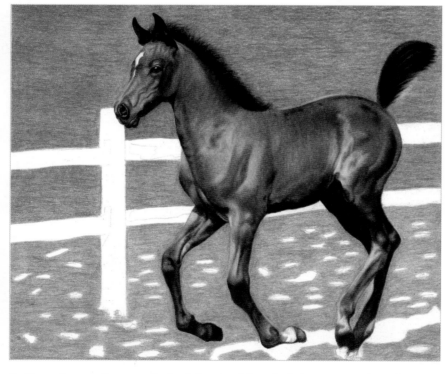

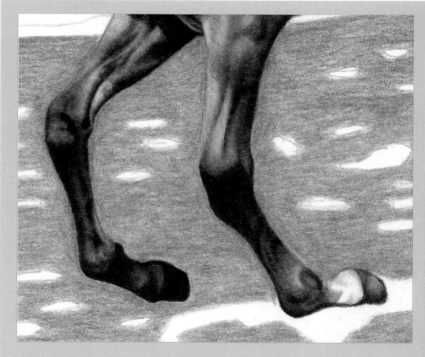

7. *I layer burnt ochre over the back legs in all but the lightest areas; then I burnish with white. I build the browns with dark umber and light umber. I use terra cotta and Tuscan red in the reddish-brown areas; then I blend with white and burnish with black over the dark shadows and left hoof. I layer in Tuscan red, black, and a bit of white for the tail. I add circles on the ground for the flowers and apply a layer of moss green and apple green, reserving white for the ground shadow.*

Detail *I layer the right leg and knee with black grape and white burnish. I use dark umber and terra cotta for the brown areas and black and Tuscan red in the dark areas; then I blend with white. On the lower leg, I layer in terra cotta and dark umber. I add black to the dark areas and Tuscan red for the reds. I block in the upper left leg with burnt ochre and terra cotta; then I burnish with white. I use terra cotta and Tuscan red for the reddish-brown areas and layer black grape and white above the knee. I use Tuscan red and black in the dark areas, and white, burnt ochre, dark umber, and black for the hoof.*

Detail *For the fence, I use peach beige as my first layer, dark brown and black for the darks, and light umber and burnt ochre for the lightest areas. I burnish and blur everything with white.*

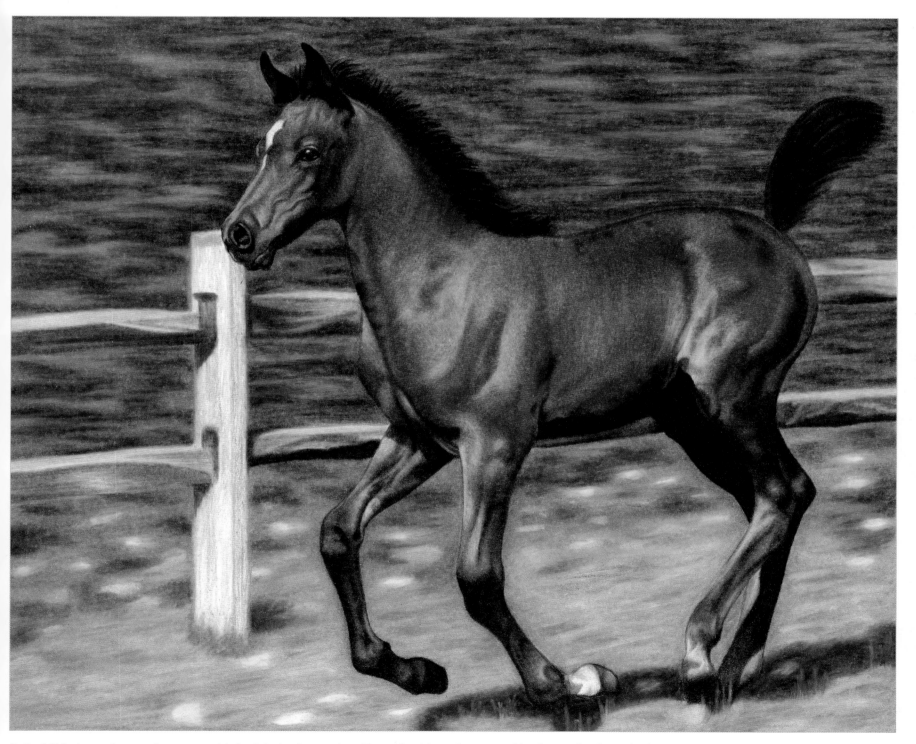

8. *I add black streaks over the top two-thirds of the background and burnish with apple green to blend. I randomly apply chartreuse and burnish with apple green to create a smooth motion blur. I use lilac with streaks of black and dark green for the ground flowers, then I burnish with chartreuse and white to blend. I create the shadow in the grass using medium pressure to layer in dark green, black, and moss green. I use white to blur, pull up color from the shadow, and add vertical grass streaks.*

Enhancing a Photo Reference

As artists, we are free to duplicate our photo references exactly as they are or make additions and corrections to create a better composition. This project's photo reference reveals two shriveled leaves, which distract the eye away from the bowl of cherries. Let's change that!

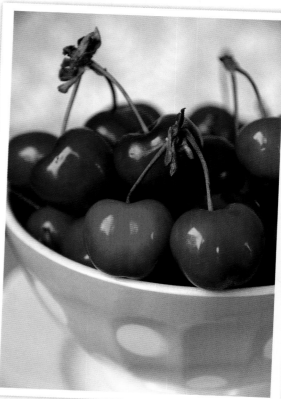

Substituting two small, somewhat blurred leaves for the shriveled ones will freshen up the composition.

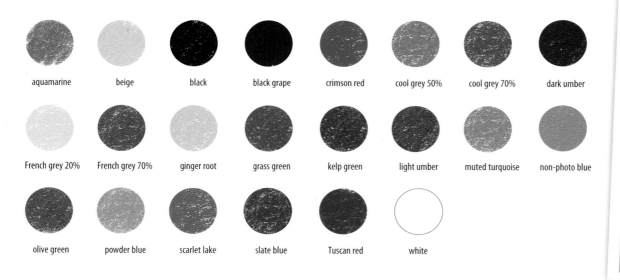

aquamarine	beige	black	black grape	crimson red	cool grey 50%	cool grey 70%	dark umber
French grey 20%	French grey 70%	ginger root	grass green	kelp green	light umber	muted turquoise	non-photo blue
olive green	powder blue	scarlet lake	slate blue	Tuscan red	white		

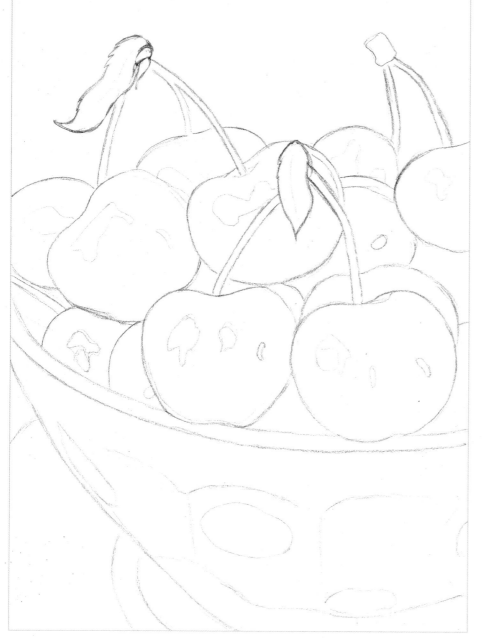

1. *I sketch the composition in cool grey 50% and replace the two dried leaves with simple leaf shapes.*

TECHNIQUE PRIMER
SKETCHING WHAT YOU DON'T SEE

Always examine your photo references. If you don't like something you see, change it. Darken or blur backgrounds to make the foreground pop, eliminate clutter, and move objects closer or farther away to create symmetry … or not!

If your application of black over red looks too dark or harsh, burnish with white then layer with crimson red. This will blend the colors and smooth out the surface so you can start again.

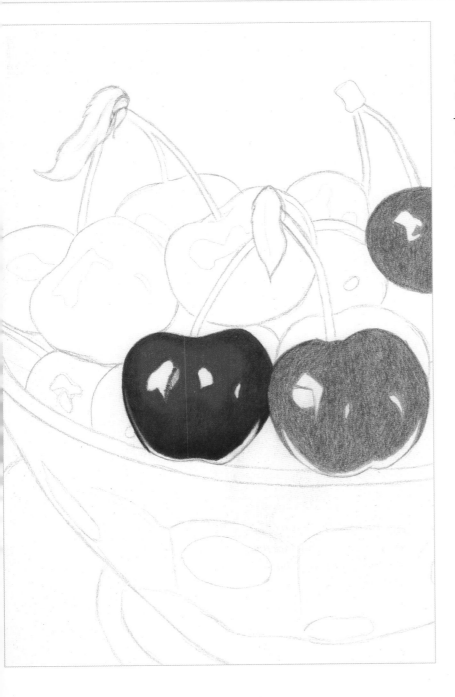

2. *I give the front two cherries and the back right cherry a base coat of crimson red with medium pressure, followed by a layer of scarlet lake and a crimson red burnish. I then layer Tuscan red in the shadowed areas using small, circular strokes and light pressure. I build the darker areas with several blended layers of Tuscan red.*

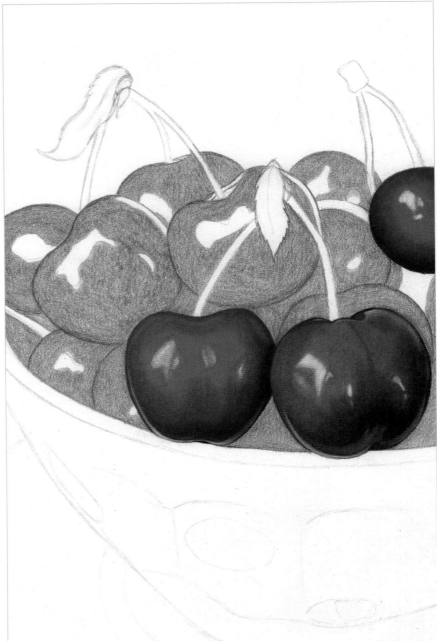

3. *I finish the three cherries with another burnish of crimson red. I apply black grape in the shadows and black over the darkest areas. I lightly fill in the bright highlights with crimson red and then burnish with white, blurring the edges. I use crimson red, light umber, and white to create the highlighted rims along the bottom of the front cherries. I line the remaining cherries with Tuscan red, then add crimson red and scarlet lake washes.*

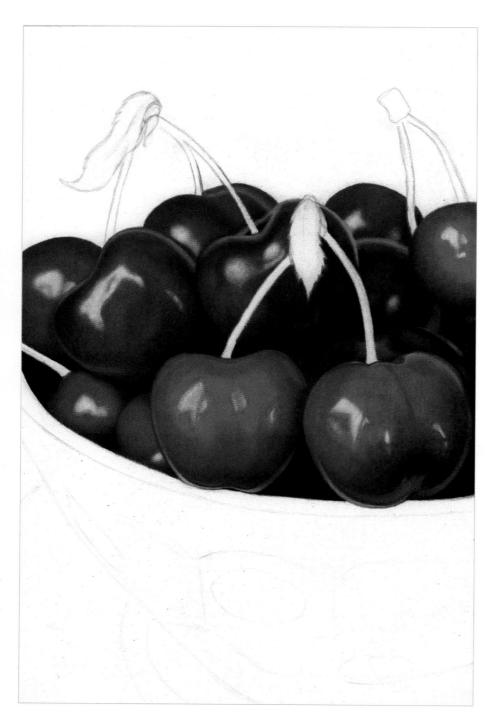

4. *I complete each remaining cherry individually, from left to right. I lay down Tuscan red, then black grape for shadows. I burnish with crimson red. I use a light touch and sharp point to apply several layers of black over the darkest areas. I add bright red with crimson red where needed. I use the same colors for the spaces between the cherries. For the highlights along the cherry rims, I layer Tuscan red, a white burnish, and light umber. I clean up all smudges and erase much of the bowl detail so the lines won't show through the color.*

– A R T I S T ' S T I P –
Burnished paper can receive more layers of black if you keep changing the direction of your strokes and layer lightly with a sharp point.

5. *I give the background two washes of powder blue; then I swirl in non-photo blue and cool grey 50% over that. I burnish with white, add slate blue and non-photo blue in the darker areas, and burnish with white. I blur the edges of the background cherries by lining the rims with small swirled strokes of Tuscan red. I follow with white using a sharp point and add a wash of kelp green to the leaves. I begin the bowl with horizontal strokes of powder blue and non-photo blue.*

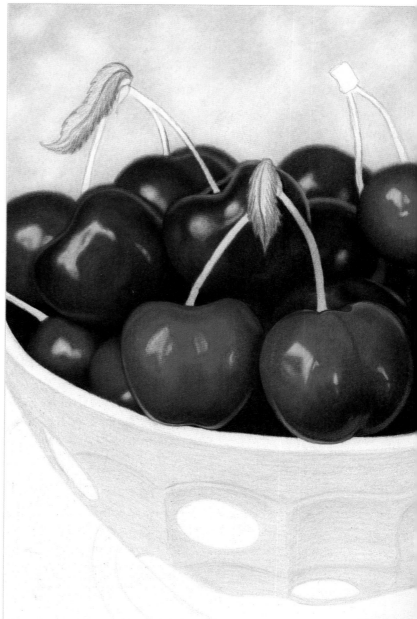

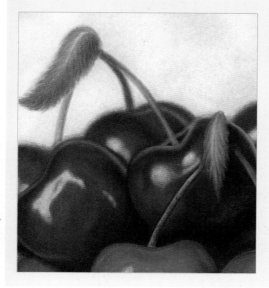

Detail *I outline the leaves and stems with dark umber. Then I apply a coat of olive green and burnish with white. I add grass green and burnish with white to blur the edges.*

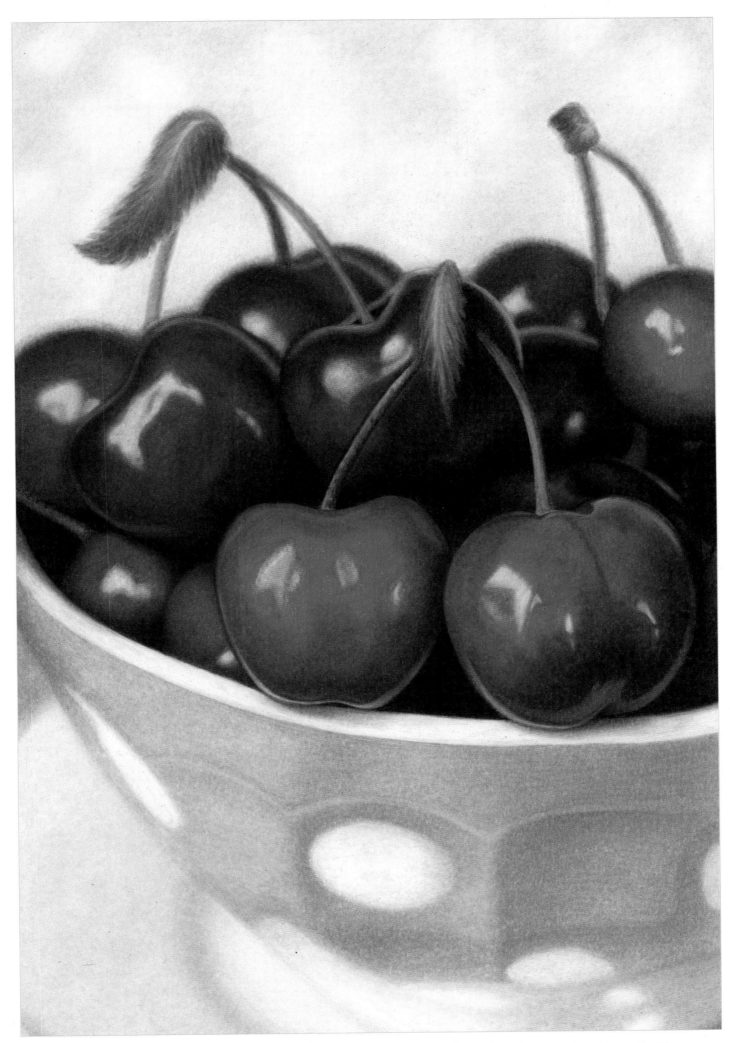

6. *I layer muted turquoise and non-photo blue over the bowl. I add cool grey 70% for shadows, burnish with white, and add aquamarine. I deepen the dark blues with slate grey; then I burnish with white. I layer white over the rim, add dark umber and ginger root in the shadows, and burnish with white. I then reapply dark umber. For the circle design, I add white, beige, and a white burnish. I layer the plate with French grey 20%, cool grey 30%, and powder blue; then I burnish with white. I add light layers of cool grey 50%, ginger root, and a white burnish to the middle area. I layer the bowl bottom with white and beige, French grey 70% shadows, and a white burnish over the entire area.*

Drawing Fur

Lucy, this one's for you. During this project, my seven-year-old golden retriever, Lucy, was diagnosed with cancer and given two months to live. I dedicate this artwork to her and pray that the natural protocol she is now on will extend her life for many more years.

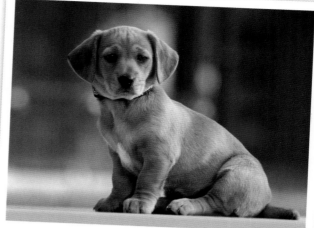

beige black blue violet lake burnt ochre

chocolate dark brown dark umber goldenrod

light umber mineral orange peach peach beige

sand terra cotta Tuscan red white

Drawing the multidirectional fur patterns shown in the photo was a challenge. I hope to simplify it for you.

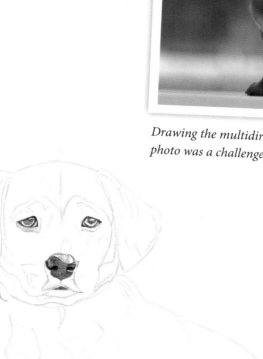

1. *I lightly sketch the puppy with mineral orange and use a graphite F pencil to add the eye and nose.*

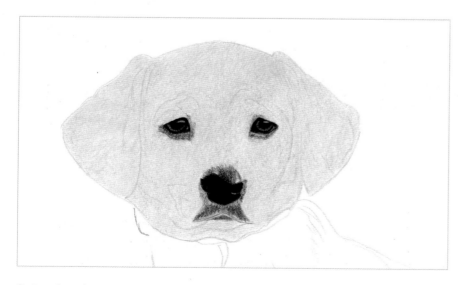

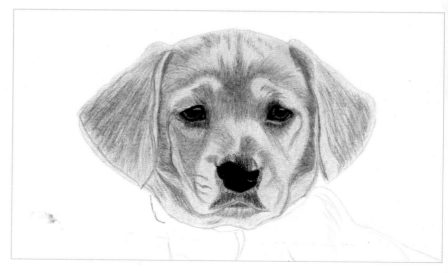

2. *I outline the eyes in black and use blue violet lake to color the irises. I build up the pupils with light layers of black and keep the catch-lights white. I finish with light black spokes around the iris, and block in the dark markings of fur around the eyes with black. I use black on the nose and white for the highlights. I begin the fur with washes of peach beige, beige, and peach using circular strokes to create a nonlinear foundation for the fur.*

3. *I block in the darks of the face and ears with burnt ochre. My strokes move in the direction of the fur patterns, so they are short on the face and long on the ears.*

TECHNIQUE PRIMER
FUR

To draw fur, first establish the color base and block in the dark areas. Midtones and highlights will follow, and blending is important. Short-haired animals will require short and quick strokes, while long-haired animals will need longer, curved strokes. Establish the initial stroke patterns and then begin to build color. Apply layer upon layer in the direction of the fur. A lovely blend of colors will develop that will resemble the animal's natural coat.

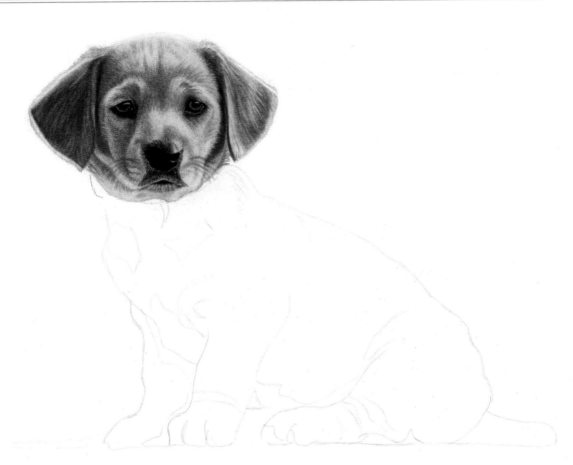

4. *I layer goldenrod over the face, using medium pressure in the dark areas and gentle pressure in the light areas. I use terra cotta over the dark red areas and bring out the eye area with more black. Beginning at the top of the head, I use beige to blend the existing colors; then I add burnt ochre and dark umber above the right eye. I use black and Tuscan red to define the area where the ears meet the face. I use terra cotta, light umber, and mineral orange for the remaining dark areas. I use beige, burnt ochre, and mineral orange for the light areas. I add Tuscan red to the outer cheek areas and draw whiskers with light umber and white. For the right ear, I use Tuscan red, dark umber, goldenrod, and terra cotta; then I blend with burnt ochre. I lightly add beige, light umber, terra cotta, and a small ridge of dark umber at the bottom of the left ear. I finish with a burnish of white above the brown ridge, and I outline the head with burnt ochre using jagged strokes.*

5. *I block in the darker body areas with burnt ochre using short to medium strokes. I then cover the entire body in a goldenrod wash using light pressure.*

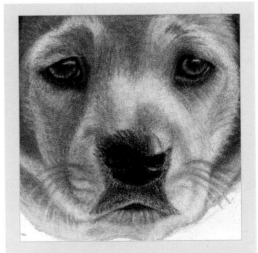

Detail *I blend the nose with white; then I add more black and blend with white. I add dark umber just below the nose following the mouth line. I use white to blend the black into the lip and use a curved line of Tuscan red below the mouth.*

6. *Beginning below the collar, I draw fur strands with burnt ochre, light umber, terra cotta, and goldenrod. I blend with sand and continue to build up the chest fur with the same colors. I apply a dark umber streak over the left indentation and black and Tuscan red over the creased fur below the mouth. I use burnt ochre and terra cotta to further block in the feet and legs. I begin to lay in the torso fur with burnt ochre, light umber, terra cotta, goldenrod, and chocolate. I burnish and blend these together with white. I repeat the process with all colors as needed to resemble the photo. I add a layer of dark umber to the lower stomach area.*

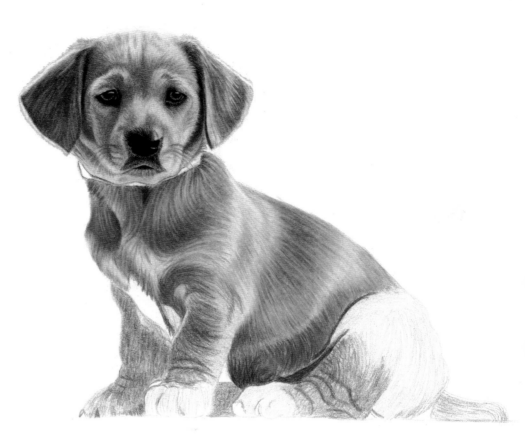

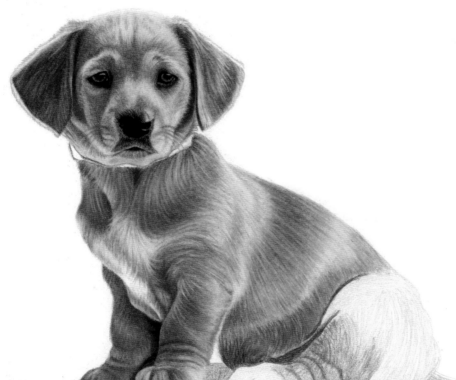

7. *On the chest, I use white to blend above the white fur patch. With a white point, I pull a few streaks of fur into the far left. I draw a few strands into the white marking with burnt ochre. For the area between the front paws, I use dark brown, Tuscan red, burnt ochre, and goldenrod. I lightly blend with white and swirl the fur out over the left paw. I use dark umber and terra cotta for the wrinkles. I cover the darker areas of the right paw with dark brown and burnt ochre. I use goldenrod on top and dark umber, black, and Tuscan red for the heavy shadow. I blend with goldenrod and use chocolate and burnt ochre for the paw. I use dark umber and terra cotta for the wrinkles and black for the toe markings and dark fur. I lightly blend with white.*

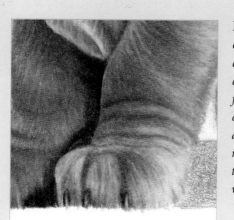

Detail *I blend the paw with mineral orange and add terra cotta and chocolate down the left side. I blend with white down the right side in the direction of the fur. I add a streak of terra cotta down the outside of the paw. I use beige, terra cotta, and burnt ochre for the toes. I add Tuscan red and dark umber in the toe areas. For the toenails, I use black and blend with white.*

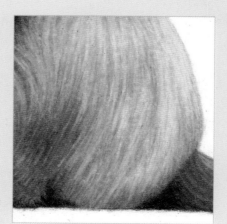

Detail *I cover the left haunch with beige then peach beige. I use chocolate and dark brown to stroke in the fur and block in the darker areas. I burnish with white. I repeat with strokes of burnt ochre, light umber, and a burnish of white. I add goldenrod to warm the colors.*

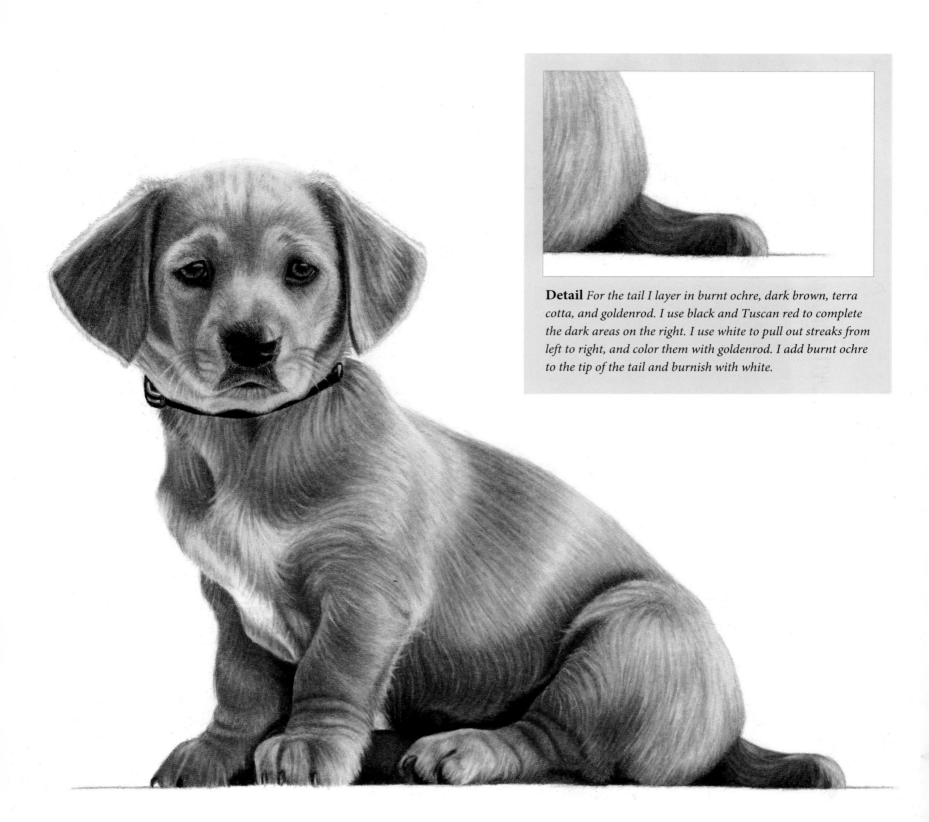

Detail *For the tail I layer in burnt ochre, dark brown, terra cotta, and goldenrod. I use black and Tuscan red to complete the dark areas on the right. I use white to pull out streaks from left to right, and color them with goldenrod. I add burnt ochre to the tip of the tail and burnish with white.*

8. *For the rear right foot, I lightly apply dark umber then burnt ochre; then I layer terra cotta and black for the shadows. I block in the dark folds on the left foot with dark brown and Tuscan red, and I blend with burnt ochre and terra cotta. I pull streaks of fur over the folds with a sharp white point. On the two dark shadows at the heel, I use black and Tuscan red. I cover the toe area with beige, peach beige, and streaks of light umber. I use white to blend and burnt ochre for the reddish brown areas. I complete the toenails with black and Tuscan red and blend with white. I block in the underbelly's extreme darks with dark umber. From left to right, I use dark umber, terra cotta, and black to create the fur and dark circular patch. I use terra cotta, black, and Tuscan red to outline and fill in the dark circular shape above the leg. I then stroke in terra cotta, dark umber, and goldenrod below the puppy's left front leg, above the haunch, and on the back. I use white to pull out streaks of fur. I color the collar with black, blend with white, and pull whiskers across it using a sharp white point. I erase all smudges and spray with workable fixative.*

~ A R T I S T ' S T I P ~

Because fur grows in many different directions, I often move my photo and drawing board sideways or upside down to better stroke in the patterns in which the fur is growing. This also gives me a new way of looking at each section and helps maintain accuracy.

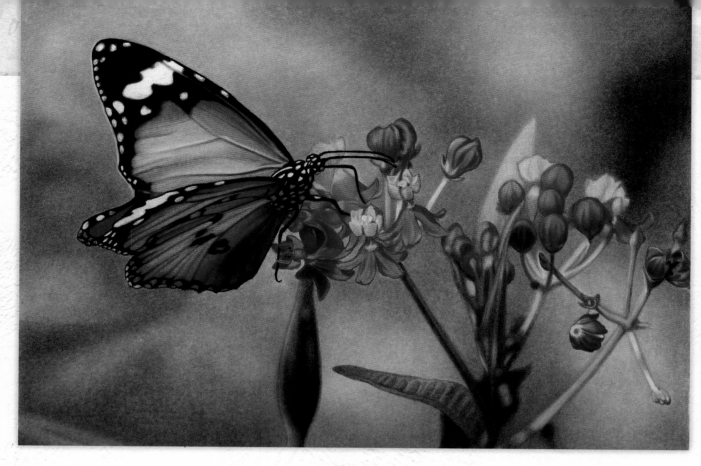

Over the years, I've learned that perhaps the most important key to success in working with colored pencils is blending. Building up color adds richness and density and transforms a mere drawing into a true painting. Also, when I get overwhelmed with the complexity of a piece, I view it one section at a time and remind myself that these are only shapes and colors. My advice is to enjoy each step of the process. When your work comes together as a final masterpiece, there is nothing like it! You'll be inspired to take more pictures and create more art. Have fun and continue to learn new techniques from books such as this one. There is joy in the journey AND at the finish line!

CYNTHIA KNOX is an award-winning artist who specializes in works of traditional realism. She is a Signature Member of the Colored Pencil Society of America, a juried member of the International Guild of Realism, a commissioned portrait artist, and an occasional art instructor. Her artwork is in shows, private collections, and on her website at www.cynthiaknox.com. Cynthia credits her passion and inspiration for art to a deep love for God and encouragement from her parents and family. She currently lives in upstate New York with her wonderful husband, Jeff, and their two beautiful daughters, Katharine and Abby.